MW00338608

# A Poetry of Birds

## Poems About Birds and the Photographs that Inspired Them

by Dan Liberthson

gatekeeper press

Columbus, Ohio

# Acknowledgments

I thank Kathy Rawlins for reading and commenting on the poems and for design ideas. Many thanks to Ron LeValley for providing the interior and cover photos.

This book is dedicated to the memory of Regina Elkan, photographer, artist, and caring friend.

Copyright © Daniel Liberthson, 2017
All rights reserved
ISBN: 978-0-9787683-4-8

All Photography by Ron LeValley

This book may be purchased on-line or via the
Dan Liberthson website,
www.liberthson.com

Printed in the USA by Gatekeeper Press, Columbus, Ohio

# Author's Preface

Spotting birds in the wild, especially uncommon and visually striking species, is thrilling and pleasurable. But birding can be challenging—particularly for people with physical limitations like myself—and frustrating for anyone who wants to observe and admire birds at length. To avoid becoming prey, many bird species seldom hold still, and can be closely studied and deeply appreciated only with major effort, if at all. Further, birds' visual gifts often enable them to "spot the spotter" and take evasive action. So I was happy to get the chance to "watch" birds close up and in detail when I began receiving emailed photos from Ron LeValley, a northern California photographer, biologist, and naturalist. Now I could sit at leisure with a different bird species every day and get to know it more intimately than would ever be possible in the wild. In time, my responses to these photos and the birds they portrayed became intense enough to generate the poems in this book.

Though I find writing a single poem rewarding, even more satisfying is writing and designing a book of poems with a common theme. Consequently I've composed books of poetry about my family and childhood, the game of baseball (an addiction), wild and pet animals, and now, birds. All of these books are illustrated, as I believe strongly that art and photography enhance the effects of poetry. So, although in this book the poems often describe in some detail the appearance and habits of the birds, I decided to include, with Ron LeValley's gracious permission, the photos that inspired the verses. As you read these poems, your perceptions of and reactions to the photos may differ from mine, but I expect those very differences to excite your imagination and enrich your reading experience. Whatever your responses, I hope you will find joy and stimulation exploring *A Poetry of Birds*.

Dan Liberthson, November 2017

# Contents

## American Bittern

In my superficial knowledge of birdkind
I thought you postured and displayed
to dazzle and entice coquettish hens—but then
I learned you are a hermit—a taciturn recluse
who grumbles in the marshlands and deigns
not display except, some experts say
a quick and furtive bow if all else fails.
In fact your neck stretches high to make
a singular call that booms across the lake
like a huge bottle glugging as it empties,
the only sign that you've come out to woo.

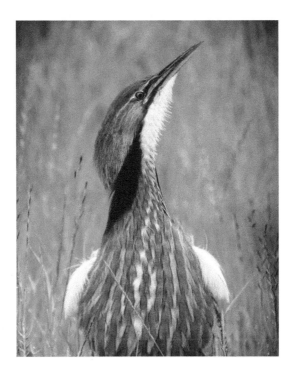

If I could reside within your would-be mate,
by mental magic occupy a she-bittern's shape,
your splendid camouflage would more impress
than any sound that skyward beak could make:
breast adorned with ropes of white and brown,
white-patched neck, head blue-gray and tan
in fine striations, dark down-curved beak
pointed at one o'clock—time she (I) gave in!

And if I chose to take your form and not your hen's?
I'd stretch my neck high but could not voice your call—
would not be one with you at all. Only with binoculars
might I admire the bold black ellipsoid on your neck
or try to sense your essence—no closer could I get.
Through reality's barrier my one half-pleasing gate
is imagination, where I can  be nearly you, or your mate.

## Northern Shoveler

Landing on this beach, you've become
flesh and feather deconstructed,
sculpted by the wind into abstract art
as thoroughly as ever Picasso or
Picabia disassembled and warped
living forms to make on canvas
improbable, outrageous new life.

Raving colors—green white brown blue
black—are so disoriented they barely hold
bird form, and this disorder's all played
back again by a further skewed reflection
stretched out on the wet and rippled strand
with even more extreme misdirection—
as if, dear shoveler, you dance partnered
with your warped image in a mad tarantella
except for those sturdy orange legs,
your one unruffled anchor to the sand.

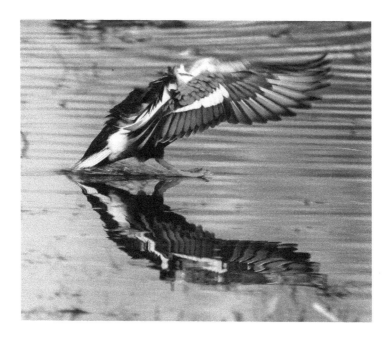

If you saw yourself as we do—
a scrambled vision on the beach
like a funhouse mirror image deformed
into confused parts we can barely parse,
a thing projected by a schizoid narcissist
or drug-addled hallucinator on the curb—
it would scare the bejesus out of you!
But lucky you: not human, not alarmed.
For unlike us when we fall crazed to pieces
you know without knowing
that you will be restored, the natural order
reasserted by artist nature—after the wind.

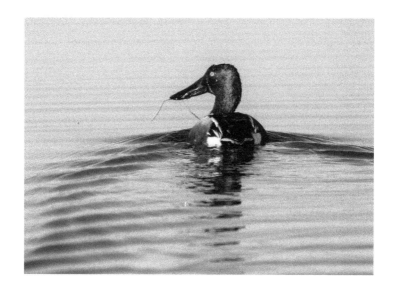

# Black and White Warbler

Like a black and white movie, more classy than showy,
you will not flaunt the riot of hues other warblers do.
A female, you're dull black crossed by soft white lines,
with pale solid patches on your neck and upper chest.
As befits a modest bird, you're not assertive but
tentative in bearing, legs spread wide to secure
purchase amid the tricky lichen on your chosen branch.
Subdued in habits too, you nest on the forest floor
in a covert spot near a tree or downed wood,
your colors barely seen amidst leaf-litter chiaroscuro.
You creep the trees hunting bugs and spiders
and probe the bark for grubs with half-crescent beak.

Your mate's colors are another story: a startling geometry
of pure white riven by hard jet-black bars that run
lengthwise on his breast, thin black-and-white slats
on his wing backs, and elsewhere crisp monochrome splashes.
The dizzying patterns flash as he flits ground to branch.
Has sexual selection made him so much more impressive?
Did urgency to court and win you drive his coloring
in so dramatic a direction, genes for stark contrast passed on
through myriad generations? I've asked, but he answers only
wee wee weesee wee . . . wee weesee wee wee!

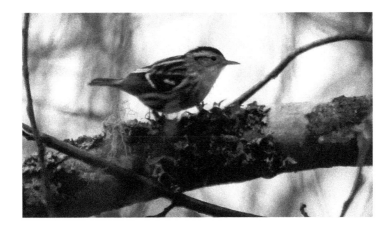

## American Widgeon

Your cream-white, black-tipped bill precedes
an ebony sickle stretching eye to shoulder,
enclosing a shimmering green jolt of a stripe.
The rest is reddish brown save horizontal
white splashmarks on the underwing's edge.

The lake's blue mirror reflects it all,
makes an underwater duck with triple crown
swim belly-up against its undistorted mate
who ignores the ripple-twisted twin below.

Look into the mirror, my human friend
and you'll see what you'd like to think
is your true, immutable self,
but rippling water's zany reflection
returns an image closer to the truth:
not the seeming you you'd love to think is real
but the mutable reflected creature
you actually are, warped by wind and chance,
your fellow man's deforming glance,
and your own threatening, thrust-down self.

Lucky drake, you will never suffer
the primal wrench of finding
you are not what you think you are,
the twisting pain of unmet expectation,
stab of self-doubt, imploding confidence.

You are right to ignore that warped double
for you truly need take no account of it.
However much the blunt wind plows the waves,
whatever shape your reflection takes, you'll remain
your buoyant self, immutable and brilliant.

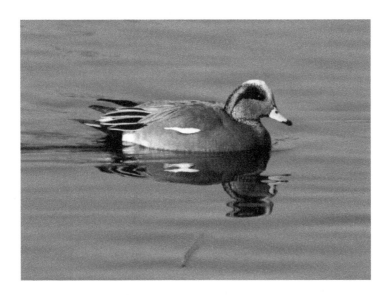

## Wandering Tattler

A photograph can lead to false conviction
or prove beauty's only in the mind, a fiction.

In this photo, Tattler, the word for you is ugly—
judge by it alone and your species must seem so.
Yet maybe you got battered by a storm, a predator
or, let's imagine, the blow of an all-night bender?
Have you been drinking coffee day and night—
depressed perhaps, or cramming for exams?
It's clear you've had no time to freshen up!
You're dirt-gray on top, soiled white beneath,
and your skull is a feast of hollows, notably
below the eyes, where cheeks should be
but a shallow trench is all I see.

Your bill is dark gray like a railroad spike
and those ordinary eyes command no admiration.
Even a still-shot suggests your gait is awkward—
like a drunk's apt to slip and teeter on the rocks.
Kleeklee ee ee, your call, is the drawn-out sound
of a rusty wheel that squeals with each rotation.

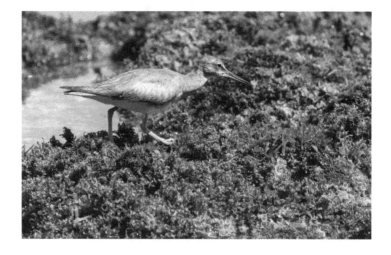

Yet, Tattler, in another photo you're a comely bird:
soft gray head, white breast rippled by pewter waves,
angular grace and skill apparent. A worthy citizen too:
though home is the rocky coast, you wander
the wide Pacific, tattling on predators with your call—
a good Samaritan, warning all. Dutiful parent as well:
the mate and you both sit the eggs and feed the chicks.
Deft among the rocks, you see to business, snare worms
and crabs, remember every site that yields the best.

With all you've done and still have yet to do, how
can you, so sleek and fresh, belie your other avatar?
Did you have a good day, sleep in, heed your mate
and skip the late-night dives, pass with flying colors
every test a fine bird must? You do your species proud!

These conflicting images force a change of mind—
A photo's seeming truth proves nothing of the kind.

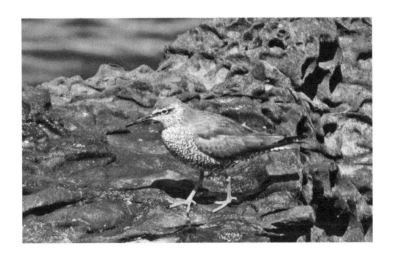

## Snowy Egret

White white white
except your dark beak
and gimlet black pupil
in its round yellow pool.

On the ground you seem
hunchbacked, and walk care-
fully on size twenty-two feet
like a stilt-legged clown.

But an unlucky lizard
impaled through the neck
by your poignard mandible
would be far from laughing.

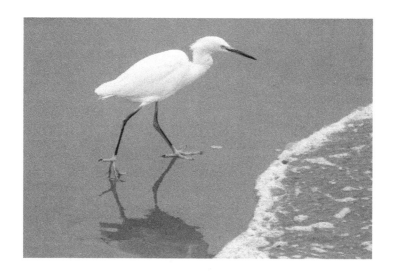

## Song Sparrow

Cock sparrow perched brashly on a branch
you sing an atonal tune of clanky bent notes,
haiku melody worthy of an avant-garde composer.
You've got milk chocolate streaks and spots
over a cream base, and a light-gray, short-beaked head
that raises a mohawk when your feathers ruffle.
Despite dominant browns, you seem a bright bird,
taut with energy. Any second you'll dive into the air
and dodge through weeds and woods pumping your tail—
an "up yours" telling predators you're too fit for catching?
Or you'll take to the ground, stroll and hop around
and dine on seeds, choice insects, tender worms.

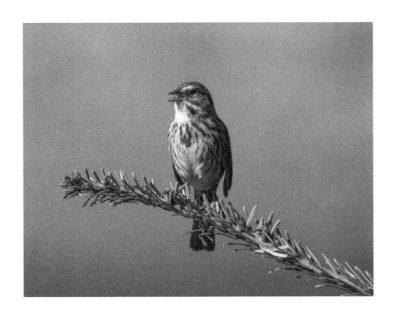

You forage secretively, calling from thickets,
but serenade hoped-for mates in the open,
risking all for conquest like any horny male.
Those clever hens judge you by both voice
and mastery of the tune. Courting, you fly
together, wings aflutter, legs dangling, tails cocked.
Mostly faithful, she still has friends with benefits,
but that won't stop her building a tidy cup nest,
sitting the eggs and tending the kids to fledging.
All you do is find a covert nest site. Then
you're history, but she'll use that place yearly
to raise two broods or more if times are good.

Your species is so common and widespread
if any could be called "Joe Bird" it's you.
Standing on a pine branch calling for a mate
or simply emblematic beside a blooming rose,
you're democratic, one among many but equal tribes,
each with its distinctions. Nature tries out diversity
in you: shapes and colors vary across regions, molded
by local factors, yet you're all genetically similar
because you tour other neighborhoods so often.
Nearby bands get along so well they interbreed,
unhindered in pursuit of happiness. A model for us?
Diverse working birds at peace, e pluribus unum.

## Brown-headed Cowbird

Your short beak tilts at just the right angle
to show you are wise to the world.

After all, your egg was laid in a stranger's nest
and you conned some other species
into raising, feeding and grooming you,
shorting their own chicks in the process.
No one knows how you did it, even you.

But here you stand on the top rail,
head feathers matching its color,
back feathers its rough striations.
Slouched back casual and easy,
have you narrowed your eye slightly
in a hint of a wink?

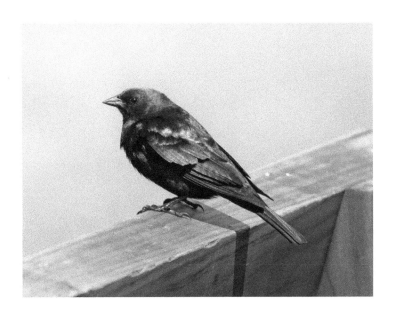

## Peregrine Falcon

You have the iron expression of an executioner
and look the role, doubly hooded with your own
dark skullcap and, flying for a falconer, leather.
Sobering, your aspect, but neutral, not cruel:
you don't toy with your prey like a cat.
After punching a pigeon or duck from the sky
with fisted foot to stun or break its back,
you finish the kill with a neck bite, blade-
sharp tomial tooth cracking the spine. Then
it's down to business, tearing first into
the most nourishing meat, breast or liver,
in a flurry of feathers moments ago rooted in life.

We're tempted to feel sorry for your victims,
the lovely drake in breeding colors, the gentle doves
you spot from lakeside cliffs or skyscraper ledges,
those hapless mice and voles you sometimes take—

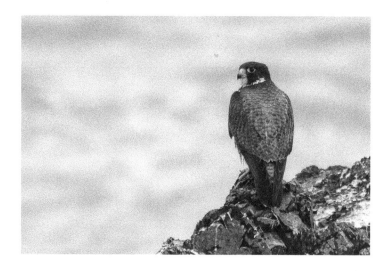

but you were not designed to eat fruit and seeds.
You have yourself, a mate, and chicks to feed
and as a courting male, the female you will woo
with soaring spiral flights, showy dives and loops.
With her, say most accounts, you'll stay for life.

So we're similar, we and you, in courtship rituals,
devotion to mate and family and carnivorous bent,
but you by natural adaptation are nowise sentimental.
Swift flash of death from the sky, you are justified—
by evolution's shaping, hunger, the will to live
and the mandate of your species to survive—
far more than we who kill from height with missiles
not to eat and live but merely to impose our will.
Of that primal sin, or any, you are innocent.

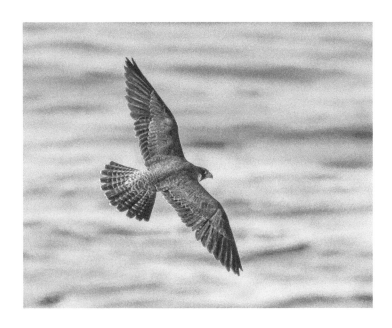

## Black-bellied Plover

Who so unobservantly misnamed you?
Your belly is pale to tan in patches
beneath brown and white latticed wings, all
atop gray stilt legs nearly as long as the rest.
Only your stubby beak and tail are black.

So nearly a sphere, your smallish form
seems a midsized ball propped on sticks
by a bored kid just passing time
as the sea of time washes over,
framing for inspection him and me.

Except, from that alertly cocked head
your round black eye lances a rearward gaze
that sets me so aback that, fixed in air,
I cannot move, held by the power there, and
dare not, despite your size, diminish you.

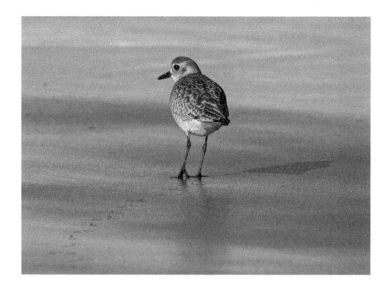

## American Kestrel

Such a small raptor, but every inch
intimidates—your beauty is terrifying!
Its complexity betokens death
for any creature you target:
orange-brown body flashing black hash marks,
scimitar wing slicing, slate gray
with matching crown strip,
white face striped with black war-paint
eye to neck and on the nape.

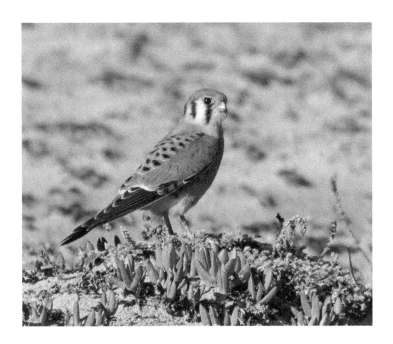

And what an eye! The black pupil
seems to dart from its yellow iris and
laser out to pierce the watcher.
Along a tail fit to maneuver and dazzle,
black and white ellipses alternate.
Short yellow legs thrust up your body
at an assertive angle, tensed for action.

No fighter jet could compare
with your fierce, live glory. It says
*I am here*, burst into the world so strongly
you cannot imagine me gone. *I defy* is
forever stamped into your brain—
I am Presence! Force! More than you!

## Double-crested Cormorants

Two in a white dead tree
perched on skeletal branches
at one and three o'clock
out at the very tips alert
staring right at something
to beware of, or to eat.

Many times your s-curved necks
have been compared to snakes.
Anchored atop dark, static bodies
the coiled readiness
certainly suggests snakes.

Beware, fish and frogs!

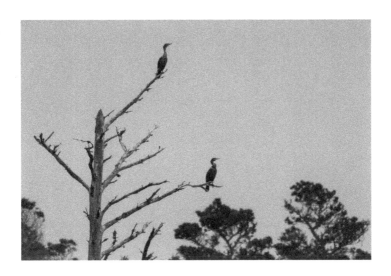

## Double-crested Cormorant in Flight

Sleek black glider banking against fog-smudged blue,
that orange beak lifts your darkness and lightens mine,
and your sinuous wing curves, shoulder to elbow to tip,
open a bloom of delight in the clay soil of my breast.
I want to soar like you, far beyond these skull walls,
and find a larger home in the high free sky.

You must feel in your flight inconceivable calm—
not a second's doubt you are where you belong.
The air appears to lift you with no effort of your own,
an ease my lurching body and pinioned soul
have never known since their planting on this earth—
can hope to know only as a shadow of your own.

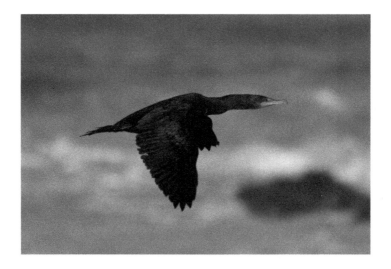

## Canvasback

As usual, drake, you get to flaunt the vivid colors:
torso like a snowy hillock, breast and rump soot-black,
neck and head a chestnut red so intense it's like
glowing coals on dark water. Startling, flame-red eyes.
Your plain mate trails behind—brown lattice over white—
but she has no need to be impressive, only impressed
in the yearly scramble for a mate to stock the nest.

You breed in prairie potholes and feed in sloughs
but winter in the ocean bays, migrating in packed flocks,
sloping profiles crowding the Midwest and Pacific flyways.
From bulky, down-lined nests in grassland marshes,
with scoop-shaped digging bill and driving webbed feet,
you dive for faves: sago pond-weed tubers and wild celery.

Not just a looker, you're smart too: in Chesapeake Bay
when aquatic plants dwindled you learned to eat clams.
The swanky set made meals of you in the 19th century and
in the 20th hunters, lead-shot poisoning, and habitat loss
shrank your numbers, but you rallied early in the 21st.
Buoyant, your brave species never reached the last straw.
You still glow in the dusk, rekindling in us a child's awe.

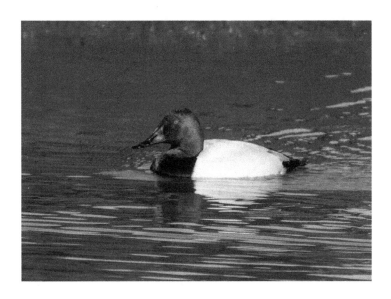

# Tropical Kingbird

There you perch, poised on a branch,
remarkable for softly blended hues.
Light gray on your head gives way to
a white neck that modulates to lemon-yellow
breast and belly, with dark and white wings.

Even your buff-colored eggs are creamy.
Craving warmth, you breed in Texas.
Is it heat that melts your colors soft,
to make you the least dramatic kingbird?

Weak and fluttery aloft, you try never to
make waves, fly under the radar and
perch low down to flitter out and catch
all manner of flying and crawling bugs.
A quiet life, but it suits you well enough.

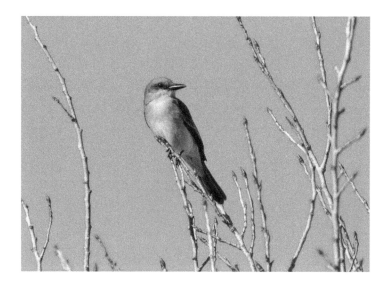

# Black-crowned Night Heron

As you swallow a thrashing fish
nearly as long as your body
your perfectly round red eye
bulges with effort beneath
a crown less black than navy blue
stretching over your shoulders
to the wing roots.

But your body is violet-blue
with white around the beak
swirled in like blueberry pudding
or a fresh can of paint stirred—
enchanting, the dark-light blaze.

Legs braced, with hardly any tail,
you pull on the prey struggling
to back out of your mouth
and free-fall through air to water—
from the killing element back home.

But this can never be,
for home is lost, fish.
Your time has come.

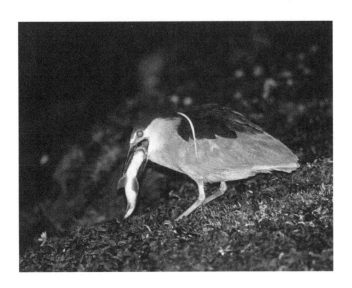

## Prairie Falcon

On a roadside post you stand at attention,
sentry surveying the field,
hunter as sure of the terrain as your own colors.
Your plumage is undramatic: overall tan to brown,
pure white belly with narrow brown splashes
oriented neck-to-tail, as if brushed on as you sped past,
off-white mustache behind a hooked beak.
A white brow line above each eye lends
to your gaze a frank, inquiring fierceness.

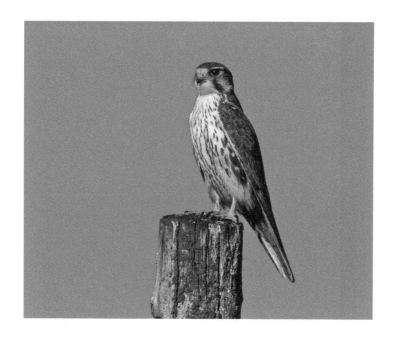

Kree kree kree . . . kik kik kik, you shrill.
Birds and mammals bigger than you feel ill.
They alarm, knowing something's amiss, but
hesitate, not certain what to do—as a soldier
facing a missile or grenade might freeze
when the only hope of living is to run—
and then are knocked cold by your fisted feet
dropping at 100 mph, no warning sound,
their heads perhaps popped off and rolling.
Or raked from below with open talons,
belly split, guts bared to insolent air,
fur or feathers blasted to a ragged heap.

So many cuddly creatures fall to you as prey
a sentimental soul might feel tempted to hate
God's or nature's order that appoints some as bait
and anoints others with an oil of predator's right,
endowed with concentrated life and savage tools
and assigned to crush the weak and the unwary,
to make life a symphony of carnage and glory,
without a qualm dispatching all your quarry.
King of the boundless prairie sky with no rival,
you're redeemed, holy warrior, by raw survival.

## Pacific Golden Plover

Migratory wader of tidal flats,
you eye me warily, circumspect
as befits a stranger in town
just flown down from the tundra.

Golden-brown with cinnamon accents
you are a bird of merely modest beauty
but knowing even that might be called back
you move with extra caution:

Take a few steps and hover,
pause to peck the mud for a treat
and then start over, keeping a low profile,
dark eyes scanning the middle distance.

All you've ever wanted is to feed, be safe,
and raise your brood, yet this middling request
tempts the gods who lord over your nest,
that humble moss and lichen lined scrape.

Despite a mild mien, you defend your chicks
fiercely—attack overflying hunters head-on
and launch yourself straight at rude human
intruders, swerving aside only at the last.

You, male, can astound with aerobatic flair,
cavorting above your breeding patch
with slow, deep wingbeats, swoops,
and sharp whistles: tee-chewee, tee-chewee.

You migrate from Alaska across the Pacific,
flying two thousand miles nonstop,
or winter on the California coast
digging mollusks and crustaceans to sustain you.

A workaday bird, you take it all in stride and don't
pretend to the osprey's glory, scourge of fishkind,
or the eagle's, lofty ravager of lesser mammals,
but without undue fuss you get the job done.

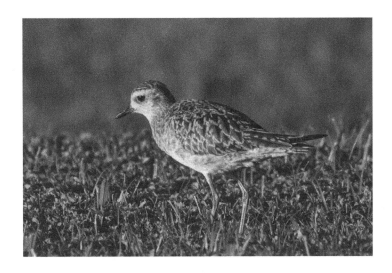

## Golden-crowned Kinglet

Little bird, so big with color, so ripe
I must overstuff a sentence to be fair to you—
I can't help singing out for every hue.
From nape to beak two coal-black stripes
sandwich a yellow one, and a violet ring
dividing neck and shoulders sets off
a broad fringe of the most delicate brown
atop sharp folded wings purple and black.
Is it the energy of vibrant, brimful colors
in a frisson of abutting shapes and patterns
that fuels your tremendous vigor?

In this fever of hues that should clash
but manage to keep calm and match,
you perch beside your moss and lichen nest,
teacup dangling from a spruce branch,
focused fiercely on a slender brown spider
drifting on its strand and no doubt feeling safe.

Despite inherent heat, alertness condenses
like ice in your small body, gaze cold and sharp
as a winter thorn or frozen pine needle.
Splendor and indifference justify your crown:
you know I watch but I'm not worthy of notice.
Your one-note, treble call insists, insists.

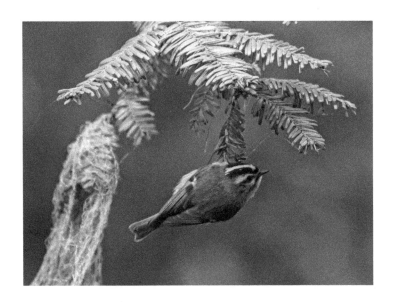

## Lazuli Bunting

A blossom rooted in faerie loam
emerges here to grace a wild-oak branch
with turquoise upper parts and wings,
off-black, oval-framed eyes and beak,
golden thorax blanching to white belly.
Flying, you make a festive pinwheel flurry
but this portrait finds you still and wary.

Atop such dazzle joy should gaily perch,
feathery heft barely tilting a shoulder
like a jolly parrot riding on a pirate,
but you enjoy no happiness at rest,
somber and consumed by melancholy.
Because you are too beautiful and know
great beauty invites the hardest blow?

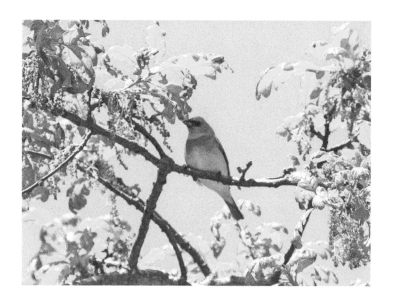

## Great Gray Owl

You should have no deathly import for me,
just for the voles and chipmunks in your diet,
yet you terrify even more than the white skull
with blank lacunae, those blind sockets leading
into endless darkness. Why would this be?

Your forcible visage? Fixed yellow eyes stare
from a wide gray faceplate marked with concentric
dark crinkly rings, like the rotating whirlwind gyre
hypnotists and charlatans use to entrance and freeze.
Gray underbody streaked with brown and white,
you seem uncannily to fly though standing still.

You embody the visceral shriek more intensely
than Munch's paintings—the hollow mask of visitation
from the shrill edge, the shadow world beneath
where nightmares breed and practice the iron grip they'll
claw into a shrinking brain. A small, pursed beak
framed by white convexities that trail to muttonchops
lends a fussy grandfather look to your targeting mask.
This comic touch merely amplifies the macabre,

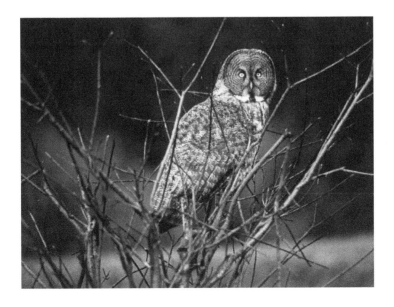

triggering a frightened, tickling giggle. You issue from
a dark portal in the cosmos' underbelly, chill land
of shrunken heads, impaling icicles, irrevocable
damnation. Grim herald, you put to shame Poe's raven,
coal dark though he be, with your deadly gray intensity.

Omen, augur, memento mori, your earthly prey
don't fear you for they can't see your dark attack
but my spirit wilts as you rise from the netherworld,
photographic negative animated by my poisoned life.
For that's your message, not just death, but death-in-life,
a greater horror: that I have never truly lived, and dwell
in an x-ray world of shades, parasitized by lies and illusions.

O Great Gray Owl, death of brightness, father of sinking,
are you the monster in my childhood closet, primed to swoop,
catch me by the nape, break my neck with one sharp shake,
dispose of all I was or hoped to be and leave me teetering
on the brink of insanity? My well-earned demon come at last?

Yet really you're a lightweight, much smaller than you look,
your monster guise inflated by plumage, a giant feather pillow
in a scary shape, dread harbinger for rodents only. Are you the
nightmare death-in-life or just a gray-cloaked bogey man
who'd fall in a crumpled heap if only I could say *BOO*?

# Red-breasted Merganser

I've seen your similar in human form
cruise the veggie aisle in a supermarket
near the kinky heart of Haight-Ashbury.
Willowy, goth-garbed boy or girl with
spiky black mohawk matching yours and
lipstick red as your scarlet beak, he or she
lacked only your crimson eye, white patches,
and the auburn chest that inspired your name.

Your colors, though stunning, aren't unique.
They're deployed by males and even females
of many species, proof the need to mate
drives evolution and culture to paroxysms of beauty
unreachable without the fierce, dense flame
in the loins lit by living matter's thrust
to make itself anew—forcing mute expression
of shapes and colors lovelier than any poetry
meant to spur the same desire as sexy feathers.

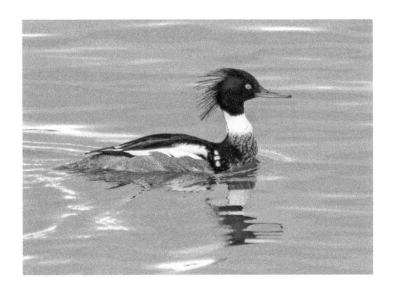

## Common Raven

Most gifted and cleverest bird outright,
you, master of deceit, dark knight of illusion,
are colored a black so glossy it seems blue,
as if it died while swallowing up the light.
And then on breast and neck some white—
but no, misled again! It's just reflected light.
Beak thick, longer than your head, a tomahawk
to crack a nut, split a breast, or part to speak.
Eye like a target—yellow-circled black pupil
ringed by the only true white your blackness permits.
Your gaze reflects frank, astute appraisal,
head tilted like a sage or savage in thought.

A passerine—three toes forward, one back—
you will eat most anything you find or catch,
rend or pluck with dexterous feet and talons.
Your wisdom extends to choosing a life mate.
Courting starts at one year but lasts a second
or more: mating forever, you must get it right.
You males make advances, but the female
gets to choose or reject—civilized respect—
and though she incubates the eggs alone,
you defend the nest and feed the young.

Many things you've meant to many peoples:
trickster and creator, lover and devious hater,
symbol of Apollo and Odin, sky gods wise but warlike.
The Tlingit say you forced covetous Seagull
to drop a box that spilled sun, moon and stars.
The world flooded with light, making day and night.

Haida elders claim you freed the first men
from a clamshell, women from a chiton,
then frolicked as you watched them mate.

Tired of carrying a stone, you dropped it in the sea
where it swelled and spread to make the firmament.
Merely your presence keeps London's Tower erect
and the green and lake-filled land of England free.
No other bird can claim so full and timeless a pedigree,
not even owl, however wise and widely worshipped she.
All hail, Raven, said to live a hundred years—
deepest of birdkind, and the one who knows us best.

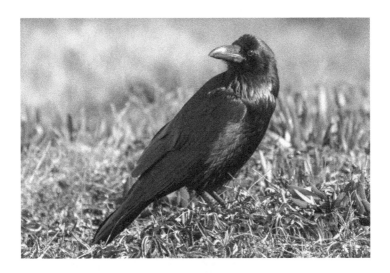

# Whimbrel

Speckled shorebird, most widespread of the curlews,
that graceful downcurved beak's your main attraction.
Barely present, you skitter like a fallen leaf, high-
stepping across the strand, stop-and-go stammering,
checking for trouble at every pause, brave only
for the halting moment you need to deftly probe
the tidal mud and grab a crab or spineless grub.

Dear whimbrel, I feel the same tenderness
for you as for my adolescent self, so unsure
he seemed at once both there and not there,
whatever "there" might be—ghosting along
ransacked by childhood, about to be ambushed
by adulthood, cringing and ducking through a world
upon which, at each step, the sky threatened to cave in.

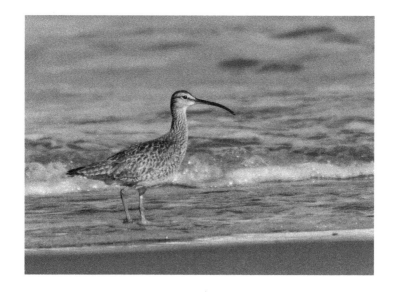

# Sanderlings

Circumpolar Arctic breeders and long-haul migrants,
you nest on high tundra in summer, eat bugs and plants,
then flee the snow, flying south along the littoral.
Plump of body, stout of bill, you bicycle the beach,
legs spinning in a blur, zipping across sand wet
from the waves you're busy chasing on all coasts,
and probe for spineless food with sharp black beak,
peeping as you go. Ceaseless motion most defines you,
for your color is not loud—light dun with brown spots,
darker across the top and verging on the wings to black,
front and back. Down their centers a white boomerang
signifies perhaps that though you fly far you will return.
Your breeding males forcefully defend their territory
but females make the laws: monogamy or polyandry rule.
Solitary on the sand, foraging obsessively, if threatened
by a falcon you condense into a flock, careen in sync helter-
skelter over the ocean and hard pressed dive into the water,
then fly off when danger's past to chase the waves again.

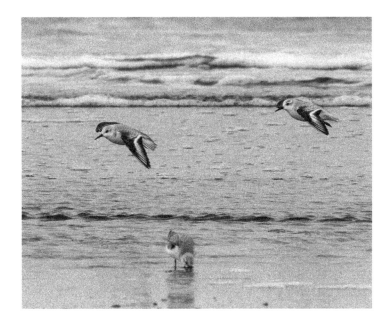

## Red-tailed Hawk

Viewed from below your broad wings
are so handsome! Rows of dark brown
surge across tan feathers
fanning back from the wing fronts.
Legs tinged with black join yellow feet
with black hooked claws and fold
back tight along your belly as you fly,
slicing air with white-slashed brown head.

Your eyes, pale yellow in the iris,
frame  black gimlet pupils that stab
the sky's soft underbelly.
A short, pale beak curves
sharply down to slash and tear
like a well-tempered scimitar.

O fierce, intent being—
you rock me back on my heels!

Without meaning to, I gasp.
How much I'd give to be your prey,
to cringe in delicious terror, paralyzed
as the patterns zoom in, entrancing.
Swoop will end in clutch, savage
keratinous beak-slash gutting,
then probing my vitals like sex.
O thrashing painful pleasure!
O lucid white death.

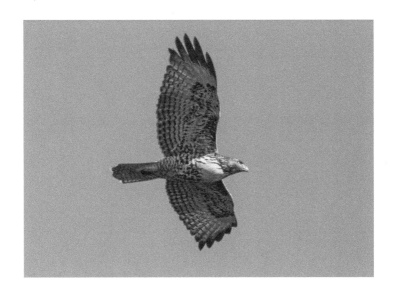

## Yellow-rumped Warblers

"Butterbutts" they call you, a most versatile group
comprised of four subspecies, one Audubon's find.
Gray-white puffball marked with black dorsal stripes,
you've yellow patches on your wings and neck front
and a crowning yellow streak atop your head. Flitting
amidst sparring branches, looping out and back,
you nip flying bugs midair and spare no crawlers.

Male helpmeet, you bring twigs, pine-needles,
grass and rootlets to your clever mate, who builds
in a conifer a cup lined with moose and deer hair,
feathers woven in to curl over and shield the eggs.
Naked hatchlings mewl and cheep, fledge in two weeks.
Destined for the same designing genius, off they fly:
Tyew-tyew-tyew-tyew, tew-tew-tew-tew cheep!

## Brown Pelican

You'd win first prize in a carny freak show—
the oddest of birds judging by your peers.
Like a grumpy old grandpa doubled over by arthritis,
advancing floppily in swim trunks and flippers,
beak echoed by the clay pipe stuck in his mouth,
squat and bent you waddle clumsily, even
grunt like an old salt to ask "treat please?"
You need only specs to complete the illusion.

Airborne, you cruise in ragged queues along the shoreline
above the shallows, heads laid back on shoulders,
bills resting on folded necks, short tails an afterthought.
As surely as your prey sense drift and dodge eddies,
with finger-like wingtips you gauge the winds
and adjust angles precisely to ride out gusts.

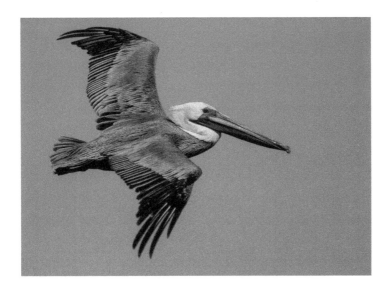

All other pelicans use team swimming tactics
to corral fish, but you sail above the waves, dive,
and apply that egregious beak, planted in black
but reddish-orange along the shaft, underslung
with famous pouch, fully admired only distended.
Sixty feet you plunge to skim the waves, nonchalantly
scoop a fish, tilt your head to drain the water,
toss the catch and stretch up your throat to swallow,
even though it looks impossible to straighten
the three hundred sixty degree bend of that neck.

The fish see only an open, onrushing bill.
Caught, they are at first tranquil, breathing calm
in your sack's pool. But as their mini-sea drains
they thrash against the inevitable until subdued,
swallowed, half-digested, puked up and
thrust down the throats of famished young.
You males pick brood sites under mangroves,
dance to attract a she-bird who builds the nest,
a ground scrape lined with feathers, edged with dirt.
Then you deliver reeds for extra nests on low branches.

Though you live in big colonies of both sexes,
pair-bonded you know the drill, needn't mix
and barely engage even with each other.
Together you feed the chicks till the week twelve fledge,
when they climb to the tree nests and practice flight—
short-hauls between branches. Coming home with food,
you parents always remember your fledglings
and feed them long after they sail on the ocean winds.

Nurturing, kindly birds, sincere and affable, you're
a bit goofy and greedy, but altogether trusting souls,
far too much like some of our bewildered elders.
Unluckily, you've learned to befriend fishermen and beg.
For those handouts, though innocent, you'll pay a price.
Snared by hooks and lines, dying, you won't even know
to blame your erstwhile patrons, those narrow, heedless bipeds.

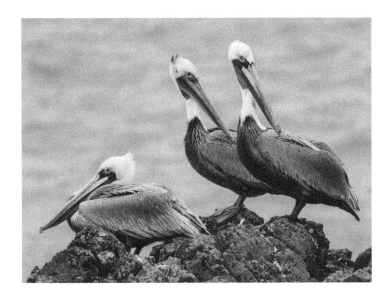

# Bufflehead

Baffled bufflehead, you ride high on the water
that seems to push you up and clear away
from the human animal on the bank whom
you suspect of lethal plans despite proffered crusts,
for you've been hunted before and know
this two-faced beast is never one to trust.

So I must admire you from afar, binocularly,
tasting with vision the unearthly, iridescent green
around your eye and ravishing violet on your neck,
sherbet islands glistening amidst black.

Like the most lovely love of my life, who left,
I could possess you only by force, but your death
by shot or trap would merely raise the pain of our gap
to yet a higher power than living loss, a razor level
at which all reward, even bitter-sweet yearning,
is cut, like that first cord that bound me to beauty.

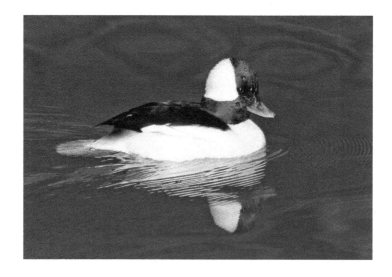

## Turkey Vultures

So grim, expressionless
as you dismantle
that dead sea lion,
it's hard to imagine
you enjoy your food.

Perhaps you feel only duty
to feed yourself and
dispose of others but
isn't this holy?
Tibetans think so.

They entrust you with
their dead bodies
to dismember and redistribute
starting another cycle of
samsara, the natural order.

Any second you will
bury your bare heads in rot,
your red heads with sunken cheeks
and dull black eyes behind
hooked workmanlike beaks.

Nothing to rave about either
in your bodies and wings:
black or brown edged with white,
your feathers will not fill
anyone's ornamental vase.

Legs purely functional,
short and stout for purchase
as you dig into your meal,
like ants, though avian, you
disassemble and carry off.

In flight you wobble, barely
remembering to beat your wings,
tails trailing your toe tips
and wings slightly akimbo—
ungainly, awkward, things.

You build no nests but lay on junk
whitish eggs, brown and lavender blotched
yet admirably you take turns
sitting on them for six weeks and then
feeding the young until they fly in ten.

Threatened, you hiss and puke—
and you do threaten easily
as befits bottom-dwelling Dalits,
but like them you have your place
and should take pride in it.

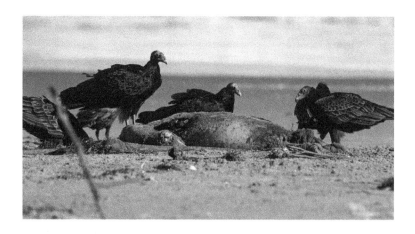

# Bullock's Oriole

Dancing, still, round-breasted girl
washed with gray and orange cream,
pretty but not delicate—compact and ultra-
alert, you cock your beak like a weapon
and boldly stare, one who dares and has no fear.

You're less emphatic than your mate
whose body's thinner and more sharply vivid:
flame orange head, neck, and belly,
jet-black upper back, wings, tail, and crown.
Different, but his gaze too is all challenge.

Agile gleaner of woodland canopies,
upside-down you stretch from branches
to weave sack-nests of grass and bark
lined with mammal fur and moss.
Insects, fruit, and nectar are your share.

Faithful for a season—whistling, chortling, scolding—
you both rear the young and chase off predators.
Sexual adventurers, across the Midwest and East
you've hybridized with Baltimore cousins.
Though no angels, you may have an aureole.

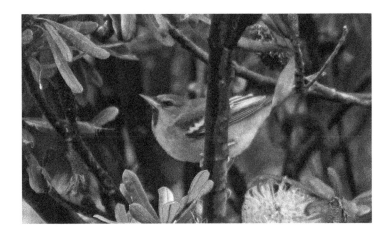

## Great Horned Owl

O great owl, the Pima believe
you're a dead warrior reincarnate
and for the ancient Greeks you were
Athena's familiar, wisdom's vessel.
Your "horns," though only feathers,
mark you as an ill portent for others—
likely the Devil's messenger,
a creature of the Dark for sure.
Perhaps untrue, but indisputably you
are a creature of mystic power—
none other haunts as well as you.

Mottled black, white, and brown,
you match the branch you perch upon
in the shadowy pool of the woodland.
Perfectly round eyes, yellow-irised
and set in shallow ovoid bowls
stare fixedly: they cannot move.
Only your lynx-eared head pivots
like the top of a periscope sweeping
those huge, nearly man-sized eyes
until they find a target and lock on.
From the gloom of your perch
those eyes consume your quarry
well before you actually strike.

Great owl, I must confess that
you're my constant watcher
and I will always be your prey,
for it's you who sees the truth.
You peel away pretense to expose,
naked to the air, all I want to hide.

Omen, your eyes bore through mine,
light up the treacherous maze behind
and expose that dodging mouse,
my hidden self that lies within—
the one that has always been
though I never let anyone see,
the one who can think and feel
the opposite of what I fake as real.

He scurries around mind's corners,
always keeps away from the light, my
stealthy mouse-self I never let show.
Is he the true me, or I—which is the lie?
Owl, your cry liquefies the marrow
of this special prey, this shrinking mouse:
he panics, turns in frantic circles
and to your cry of *who, whoo*,
can answer only *I can't tell you*.

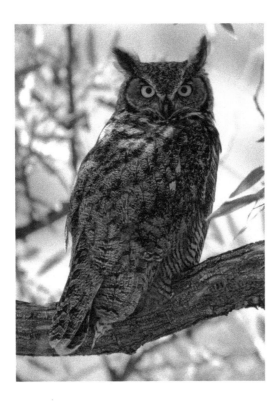

## Anna's Hummingbird

You perch on a budding succulent.
Everything reeks of spring.
A violet velvet gorget rises
from thorax to neck to head.
So many light-inflected purplish shades
adorn you, from almost brown to
nearly screaming neon pink.

Your off-white body is green-flecked
and whorled with yellow-green.
Orange-white feet clutch a stalk,
framed against a black undertail.
With startling black eyes
dominating and impervious
and a black thorn-sharp beak
you're like a fairyland warrior
set to rush and skewer invaders.

O you feisty little fucker!
You're a heartbreaking wonder
with that tininess so full,
metabolism high velocity,
energy strumming through,
willing—no, happy—to murder
in defense of your patch
though your own death's
just a fist squeeze away.

Oh so small, so big, so vital!

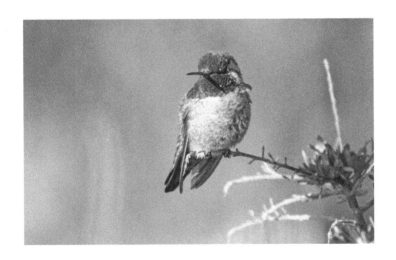

## Ruddy Duck

Wildly colorful drake, you boast a glossy black cap
setting off white cheeks, chestnut-red back and sides,
and most impressive, a turquoise-blue scoop-bill.
Small and compactly ovoid, you bob in the water,
head nestled into your body so from some angles
it seems to grow from the middle of your back.

You are in summer plumage, my bird book tells me,
and that you, American bird and strange little diver,
are lazy and disinclined to fly, which does take work—
beating across the water to get airborne and then
frantically pumping stubby wings to stay aloft.

Your courtship displays are comical (no offense meant).
Tail raised over back like a flag, you bounce your head
so fast that bill slaps chest, then rush over the water
in brief bursts with showy splashing of wings and feet.
So cute and cuddly, bobbing around like a bathtub toy,
no one guessed what a hustler you really are until
Sir Peter Scott brought you to England in 1948.

You bolted from wildfowl collections, proliferated,
spread to the Continent, and by relentless courting
cross-bred with rare South-European white-headed ducks,
provoking conservationists to such alarm that they
sentenced you to extirpation and quickly carried it out.
Despoiler no more, you await the next foolish human
to be hoodwinked by your charm and take you home.

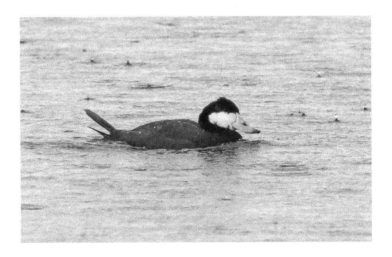

## Great Blue Heron

For god's sake! Your gray, s-curved
neck uncoils thick as a cobra
behind a long orange beak forked
around a gopher caught by the scruff of a neck
perhaps already broken—the rodent hangs limp.

Yellow-rimmed and black-pupilled, your eye
gazes sternly, no hint of mercy there.
The white under-neck patch descending
must terrify cringing prey
if there is time for terror
before the dagger beak skewers.

Another of your kind I saw spear
a frog lolling in the pond
in front of the Asian Art Museum
as if just caught in paint by Hokusai
though this was no clever illusion
but real as death can be.

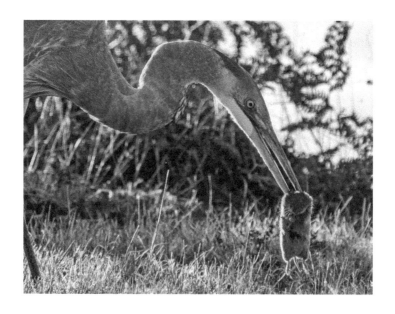

## Common Goldeneye

You, male,
are a study in black and white
except slight viridian shimmers
on your throat and head and
gold irises surround the black
islands of your pupils.
White wings with black running bars
respect the restrained pattern but
it's shattered by silly orange legs
trailing off the stern, just visible
as wavy blurred jello sticks
antic in knock-kneed paddling.

These legs you try to counteract
to keep your dignity intact
by holding fast to a pose and mien
often seen in antique aristocrats
weighed down with guarding family honor
in portraits stiffened for that task—
or judges, who must convince us all
they epitomize the fairness of the law.

This expression I can only describe as
solemn.

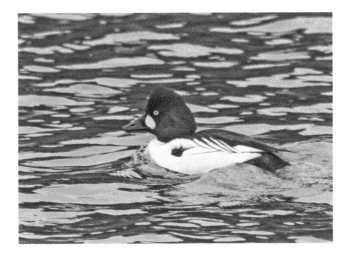

You, female,
might be taken for another species
except your peculiar domed head's
the same shape, but it's colored
solid brown like your bill and neck.
Elsewhere light brown prevails,
crossed by frothy-edged white bars
like agitated seismograph traces—
as if you know, too deeply to permit
any attempt at self-delusion,
that all this calm, pastoral scene
could fracture at the whim of wind,
wild storm, bobcat, echoing birdshot.

In common with so many females
wise in birthing and raising young
you seem to know the risks at hand,
acknowledge them without denial
(your male's reality-defying stand),
and prepare to face the worst or best.
And what of solemnity? None.
As expected by anyone who has
deeply seen and read you,
your expression's different—more
apprehension.

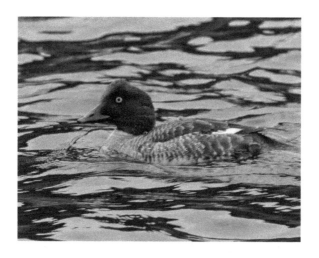

## Atlantic Puffin

A misnomer, for surely you puff out:
the white of your hemispheric belly
balloons—a marshmallow bouffant.
Eyes hidden in black crevasses
mar the snow-white sides of your face.
On an outsized grooved beak, sail-shaped
fiery red-orange banners run from tip
to middle, ramming a yellow ridge that in turn
shoves a black triangle back against a second
yellow ridge just in front of your head,
forcing the red to spill down and coat
the shocking bright O-ring of your mouth.
Rube Goldberg contraption assembled
by a purblind fabricator, you seem built
from leftover parts of other odd creatures
binned for future use—an afterthought.

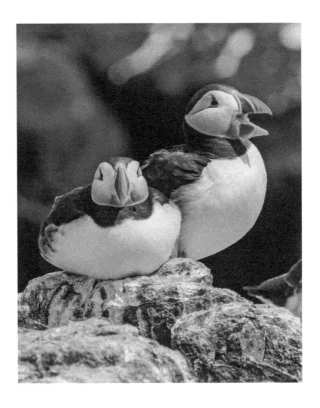

In Spring your jazzy schnozz lights up like neon
for the mating game, but all winter it dwindles
and darkens as the brilliant cover plates molt.
Solitary, you float at sea—marine hermit,
lone bobbing cork. It's preen or sink,
fish or starve, savor or endure your isolation
till Spring comes once more, time to strike out for shore.
Then your short wings, better for swimming
than flying, whir like a crazy rotor, driving
arrow-straight flight ten yards above water
ever shoreward. On the way, pure klutz,
you can't stick your landings—
graceful gulls laugh as you crash wavetops
and flip end-over, or belly-flop on calm water.

Like a long-haul trucker on a bicoastal trip,
back you wend to the same shore you left,
the same burrow, remodeled from a rabbit hole,
the same life-mate—loyal to her and your colony
but mostly to your own bit of earth,
the sole fastness in your ever-cycling life.
You leave the burrow when the chicks fledge
but hurry back to breed. On this bifurcated path,
which branch do you prefer, social or solitary?
Particolored pagliaccio, do you mourn inside
while waving your merry rainbow beak?
Or, despite a solemn mien, are you inwardly
happy with your lot, freedom's laughter ringing
in your heart? Do blind urges drive you out
and in, or do you get to choose your own way?

# Adventures of the Wild Goose

*My heart knows what the wild goose knows*
*And I must go where the wild goose goes.*
　　*—Terry Gilkyson*

*I have been faithful to thee, Cynara! in my fashion.*
　　*—Ernest Dowson*

### 1

In my early teens, we lived way north
toward Canada, and every Spring we saw
and heard wild geese very high and far,
against sunset, dusk haze, or storm clouds,
sometimes silhouetted by a full moon.

Their voices haunted the evening air,
tugging on my heart as if rekindling
an ancient, mysterious need to wander,
to follow them to unmapped lands
sailing before the wind, mainsheet in hand.

Never mind that the geese felt no mystery.
They'd flown this route since ancient times,
knew every mile, and made the journey
not to escape but to arrive at their land
of milk and honey, to rest, eat, and mate.

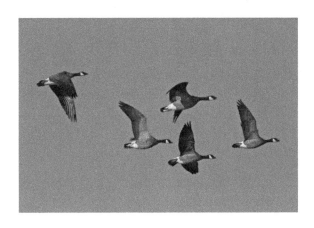

They are married couples, loyal for life
my parents told me wistfully, as if
among people such a union was sought
but seldom found. Goose monogamy
confirmed by the Britannica, I spent

an afternoon studying photos, admiring
the birds' snow-white chinstrap and band
just forward of the tail, startling in a body
otherwise dark, solid brown or mottled,
and that fiercely thrusting neck, so black

in some lights it had to look nearly green.
Their size and power, the broad wings
beating with force, were like Zeus taking Leda
in a painting I'd seen. Yes, he was a swan,
but he could have been a huge wild goose,

outstretched neck plunging at the final gasp
before he backed away and turned to fly.
He pleasures and leaves, untethered, no need
to atone, for she loves it too, though acting
demure maiden. Mouth wide, face flushed,

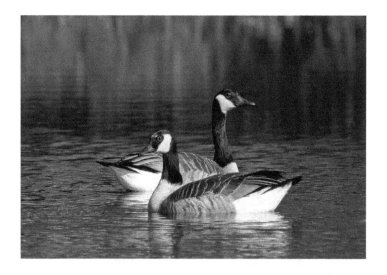

she reaches out, longing to yield to him again,
to taste a last hot embrace before parting.
But he, ready to be free, brushes her
eager face with a wing tip and, leaving
only memories, rejoins his goose mate.

<p style="text-align:center">2</p>

My father when very old, a week before he died,
raised an odd, small smile that edged aside
cancer's pain a bit. He murmured a line
of a rusty old song from well before my day:
"Oh, I want to go where the wild goose goes."

He used to intone that embracing my mother,
then grin archly as if it were a secret code
only known to them, but I had to wonder
why he would say that as he showed his love,
for it seemed to mean he yearned to leave her.

"I have been faithful to thee, in my fashion,"
he said at other times, as if he meant *her*,
but in a book I found those words in a poem
about longing for another, lost beyond hope:
some great love long past, not my mother.

Did she sense this phantom rival behind her?
And if she did, as he pulled back did she say
to her own silence, he's just a man: hold them
too close and they break away; let them go
and if there is no other they might stay.

I grew up, adventured, found a mate and stayed,
but still longed for the far skies as he had, and like him
I couldn't show my love without inward shying,
aching for another place and time, a woman more kind
or another who seemed perfect now, one left behind.

Some years I envied the roaming geese, flight planned,
track clear, for I felt numb and lost, fat in the land
of milk and honey. Midway on my path, the trackless
regions came to me, not I to them, and stranded my soul
in a sea of sand, cast down in a deep and blinding hole.

The dark years passed, and then I found a verge, not sand
or oasis, but a green strip between, less of bliss than peace.
Spared the razor cuts of longing and wild dreams,
I found comfort there and at last, at times, some ease—
but the wild scent of the westerlies still teased.

Nearly Dad's age now, I nestle in this place, justify
my life, tell myself I'm lucky to be in a land of plenty,
there to live and die—I've done enough. But the geese
still call me to fly to some impossible sky and find
old love or new. Did Dad at last arrive there? Will I?

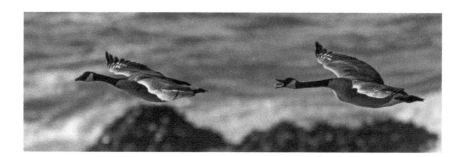

# About the Author

Born in Rochester, New York, Dan Liberthson attended Reed College, Northwestern University (BA, history) and the University of Buffalo (PhD, English), and now lives in San Francisco. His poetry and writing are driven by a few core beliefs: the importance of telling a story, the need to tell it in a disciplined way, and a conviction that the sound of the language, too often neglected, is an important and forceful agent of poetic expression.

Dan has published four prior books of poetry. *Morning and Begin Again* (2012) explores ambiguity and ambivalence in human life. *Animal Songs* (2010) delves into the powerful presence of animals in our lives—they help us realize what it means to be alive. *The Pitch is On the Way: Poems About Baseball and Life* (2008) explores baseball and what the game means to its fans. *A Family Album* (2006) comprises poems about Dan's childhood in an American Jewish family with a schizophrenic younger sister. All of Dan's books can be ordered via his website, **liberthson.com**, or from major on-line distributors.

# About the Photographer

Ron LeValley is a biologist who specializes in photographing wildlife of all kinds, from whales and birds to insects and natural scenes. Now living in Little River, California, he has been a professional photographer for 45 years, compiling over 70,000 images of wildlife and nature. Known for his work on the identification and distribution of birds along the Pacific Coast, he also has a lifelong interest in marine birds and mammals, enhanced by his involvement with Point Reyes Bird Observatory from 1966 on, including service as a biologist at the Farallon Island research station. Ron founded and for 15 years directed Biological Journeys, a pioneering ecotourism company, and was a founding member of the Mendocino Coast Photographer Guild and Gallery in Fort Bragg, CA. His work is exhibited there and at other venues in Northern California. Prints of Ron's photographs can be ordered via his website, **levalleyphoto.com**.

CPSIA information can be obtained
at www.ICGtesting.com
Printed in the USA
LVHW071927180620
658457LV00026B/504

9 780978 768348